THE FARMER'S YEAR

THE FARMER'S YEAR
A CALENDAR OF ENGLISH HUSBANDRY

WRITTEN AND ENGRAVED BY
CLARE LEIGHTON

LITTLE TOLLER BOOKS
DORSET

First published in 1933 by Collins

This edition published in 2018 by Little Toller Books,
Lower Dairy, Toller Fratrum, Dorset

Text & Wood Engraving © The Estate of Clare Leighton 2018

Set in Poliphilus Monotype and Blado Monotype by Little Toller Books

Printed in India on 140 gsm paper

All papers used by Little Toller Books are natural, recyclable products made
from wood grown in sustainable, well-managed forests

A CIP catalogue record for this book is available from the British Library

All rights reserved

ISBN 978-1-908213-67-9

NOTE ON THE TYPEFACE

The principal typeface in our edition of *The Farmer's Year* is Poliphilus Monotype, which was originally created in the late fifteenth century by Francesco Griffo da Bologna, while he was working for Aldus Manutius at the Aldine Press in Venice. The typeface was first designed and cut in metal for an edition of Francesco Collona's *Hypnerotomachia Poliphili (Poliphilo's Strife of Love in a Dream)*. Francesco Griffo also cut a new italic type for the Aldine's 1501 edition of Virgil, a small octavo which pioneered the fashion for publishing classic Latin and Greek texts as pocketbooks.

In 1502 Francesco Griffo parted company with Aldus Manutius, and although he continued to design and cut new type his career ended in disaster in 1518 when he killed his son-in-law during a quarrel. His name marred, his talent forgotten, it is only in more recent times that his influence on typography has been recognised, and he has since been described as the first modern typesetter, having devised types for the mechanical craft of printing and not as an alternative to the handwritten manuscript.

Contents

JANUARY: *Lambing* 7
FEBRUARY: *Lopping* 13
MARCH: *Threshing* 17
APRIL: *Sowing* 21
MAY: *Sheep Shearing* 25
JUNE: *Haymaking* 31
JULY: *Cottage Gardens* 37
AUGUST: *Harvesting* 41
SEPTEMBER: *Apple Picking* 45
OCTOBER: *Cider Making* 49
NOVEMBER: *Ploughing* 53
DECEMBER: *The Fat Stock Market* 57

JANUARY *Lambing*

MRS DEWEY tossed in bed. The windows shook in the gale and the rain dripped from the eaves and drove against the panes. Joe had left the garden gate ajar and it swung regularly in the wind with a sharp moan. In the blackness all sounds seemed louder and she shivered as she turned once again in the bed. How cold the sheets were. She tucked her icy feet up in her flannel nightgown. At the far end of the bedroom the two children stirred in their sleep. The wind drove the rain down the chimney so that it pattered loudly on the iron grate. From time to time a choking sound came in at the window; it was Daisy, the brindled cow, coughing like an old woman.

Bessie Dewey waited and listened. Would Joe never come to bed? She struck a match and looked at the watch under her pillow. Twenty-five minutes past two. And the third night this week that Joe had been up with Daisy. And there was Sloe about to calve any night now. Why would they always seem to do it at night? And why did it always rain? There was Joe getting as bad a cough as that old cow and no question.

The match went out, blown by the draught. The rattling of the blind irked her; it would wake the children. Shivering with the wet cold, she dragged herself across the room to the window and pulled up the blind. There was Joe's lantern gleaming from the cowshed. How it sparkled through the wet pane. She swung her eyes across the blackness of the window. Over in the top right-hand corner a second light sparkled and flickered. The shepherd was at work with the lambs.

In another bedroom Mrs Castle, the shepherd's wife, would be lying lonely and cold, listening to the wind and the rain as they clamoured at the window.

Mrs Dewey lit a candle. She could not sleep.

Out on the wold the shepherd sat huddled in his hut over the charcoal stove. He saw the flames of Bessie Dewey's candle.

'Farmer be having a night of it again with Daisy,' he muttered. 'Well, that old cow be giving him trouble, she do.'

A bleat roused him. At his feet by the stove lay his latest newborn, lanky and damp. He turned it over and stretched out for the bottle of warm milk. First trying the teat himself, he placed it in the lamb's mouth. Tenderly, with all the wisdom of over fifty lambing seasons, he seemed to breath life into the huddled mass of legs, gently caressing the tiny body that was hardly as big as one of his own hands.

On the roof of the hut the raindrops fell noisily as bullets. A piece of loose tin flapped in the wind.

Satisfied that the lamb was living, the shepherd flung one sack across his shoulders and tied another one round his waist and took lantern and lamb out into the night, to place the creature against its mother. The wind blew his beard across his face and the rain blinded his eyes. It was by touch rather than by sight that he made his way to the lambing pen and found the mother sheep.

Several ewes were just coming on to lamb. He would have very little rest tonight. He walked among his flock, stooping over some of the heaviest-sided ewes as they lay dozing, their hearts shaking their bodies like pumps as they throbbed. In the shelter of straw and hurdle, dry and warm against the rain and the cold, several ewes stirred apprehensively, knowing that their time was near.

The shepherd's ears listened and heard a faint noise at the far end of the lambing pen; a ewe had dropped twins. The big, ungainly

man with the gentleness of a midwife was with the ewe in her labour. His lantern revealed a trusting-eyed sheep and a quantity of awkward black legs attached to two minute wrinkled bodies. The sheep made a movement of protest as he lifted her lambs from her, but the kindness in the shepherd's eyes overcame her instinct of fear and she lay back unresisting.

The next few hours showed him wading to and fro through the mud between lambing pen and hut, as more ewes came on to lamb. Heavier and heavier grew his sleep-cheated eyes, and he would doze for a minute or two in his hut, to be roused by Floss the sheepdog rubbing her nose into his hands to tell him she heard a sound from the ewes. The wind whistled through the hurdles of the lambing pen. The small circle of light below the lantern he carried served only to blacken yet more deeply everything beyond its radius; and when dawn came it brought with it no sense of clearer form: the black merely turned a grizzly grey and the steely darts of the rain pierced the shepherd's protecting sacks yet more keenly.

Over the wold at the farmhouse a small light reappeared.

'There be Farmer Dewey a'gettin' up,' said Shepherd Castle to himself as he nearly dropped a newborn lamb from his numbed hands.

In the farmhouse bedroom Bessie Dewey lit the candle.

'There be Shepherd out there still with they lambs,' she thought as she saw the gold star of his lantern move across the window. She shook the farmer, to waken him, but sleep had him still in its grip. A whistling below in the yard told her that Tom the cowboy was up. She tore herself from the warm bed and with chattering teeth covered herself with layers and layers of clothing. Tiptoeing across the room, she unlatched the door and shivered her way downstairs to the farm kitchen.

Tom, the cowboy, was feeding the cattle. In the stables and sheds steam rose from the warm bodies of the animals as he unbolted the doors and let the cold air rush in. The wind blew out his lantern through a crack in its glass, and he stumbled as he groped his way back through the mud of the farmyard, sprawling and splashing his age-green overcoat as he went.

Outside the kitchen door, on the yellow-flowering jasmine, sang a robin. The rain was stopping, and faint bands of primrose lay across the sky towards the east. In the kitchen Farmer Dewey and his wife and family, Roger the ploughman, and Jane the dairymaid, were at breakfast. Tom joined them, bringing a trail of wet and mud in with him.

The rain passed and a few days later saw the shepherd peaceful and happy once again

'Never mind how cold it be,' he almost prayed each year, 'so long as I have dry lambing. They lambs don't mind the cold. It be the wet what do the mischief. Why, I've known lambs hopping and skipping about that happy like, when my face has been real blue with the cold and my buskins be fringed with icicles before I be really outside the door of my hut.'

It was weather such as this that was making the shepherd so serene. The few hours of pale winter sunshine stroked the backs of the weighty sheep and gilded the straw of the rick that was in the lambing pen to be cut for bedding. The straw-backed hurdles stood so square and protective that they seemed maternal. 'Fear not, little flock,' the sheltering pens seemed to say. 'Outside is the frozen wold, the worry of dogs and men, markets and butchers, knives, ropes and big distances. Here there is rest and peace and warmth, and no one shall come near you.'

The lambs gambolled idiotically, kicking up their hind legs and wriggling their tails, plunging at their dams for nourishment, kneeling down by their side so they might reach their mother's dugs.

In clumsy exuberance a lamb would rush at the wrong dam, to be butted by her for its pains.

Through these short hours of light the shepherd would bring fresh bedding to the pens, or feed his ewes with white turnips, or fold a new bit of field to house his growing nursery. When the early afternoon sun sank crimson behind the rime-covered ricks, the rapid dusk sobered the lambs in the pen and the ewes settled themselves down to rest. The shepherd, intent on a night of sleep, made a last round of his flock. Across the wold, dark against the skyline, he trudged homeward. Over that well-worn path along the ridge, Pagan and Christian, Celt and Saxon, forerunners of his craft, had trudged since first the great stones went up round the Druids' circle on the moor.

The carter was putting up his horses for the night as the shepherd passed the farm.

'A cold night,' said the shepherd.

'Oh, aye, a cold night,' echoed the carter.

The shepherd disappeared into the winter darkness.

FEBRUARY *Lopping*

AS the days lengthen the cold strengthens, is an old country saying. February brings the severe frosts and the snow. Ponds are frozen over and the village children make slides down the lanes on their way to school. The blacksmith finds that people pause and enter his smithy for a gossip, thawing themselves near his fire; and there is something particularly welcome about the warm smell of new bread from the bakehouse.

Old Mrs Quex has three oil stoves alight in the village shop, but still her fingers let the knife slip as she cuts the cheese or the bacon. When the bell-ringers gather together for practice in the church in the evenings, there is a loud beating of arms and hands to bring the blood back into finger tips.

But while the sun glows low and red above the frozen fields there is shelter and comparative warmth in the coppice. Here men are busy felling the undergrowth. Black they look against the thin covering of shining snow on the ground, all varieties of colour lost in their contrasting depth of tone. There is no privacy while this white blanket is laid over the earth. The clearings may be silent of rabbits during the daytime, but the patterning of the smooth surface of the snow by small pad marks, three to each rabbit, tells of animation in the crisp frosty moonlight. Since the last snowfall in the late afternoon, there are telltale prints down the lane to the wood, where John has walked out with Jenny, and what the winter twilight kindly hid has been shown to the gossiping village in a trail of clustered footmarks, two big, two small.

Birds forget their timidity under the urge of hunger, and hop and flutter among the feet of the woodmen. The snow is imprinted with lacy designs where they have hopped, deeper and bigger for blackbird and thrush, intermingled with the delicate signatures of chaffinch and tit.

Hedging and ditching, lopping and clearing: these are February's work, for they can be done in frost and cold, when the blade of the plough would fail to turn the hard, resisting earth, and the litter lies frozen to the farmyard, so that it cannot be carted into the fields.

The hazel undergrowth is thinned and stacked into faggots and bavins and left to 'dry out' in the coppice. Through the woods comes the sharp snapping sound of the chopping of small branches, broken occasionally by the distant boom of a falling tree. There is no quietness in the thickets just now for the little things of the earth, the rabbits and foxes and hares.

In the middle of the field down by the watermill stands a lonely scarecrow. Prominent and dark against the white of the snow-covered land, it looks a cold, pathetic object, less protection against the ravages of the birds than the snow itself which covers the lately-sown grain. A mistle thrush ironically sits on old 'mawkin's' weatherworn bowler hat, singing out across the still fields. The snow lodges in the straw stuffing which has broken through holes in the tattered old coat. The birds watch the field, and at the first sign of thaw they will descend upon it in a dusky cloud to pierce through the softened, melting snow and find the seed grain. Against their hunger the scarecrow stands impotent.

Gaunt willows border the mill stream. The piles of willow hurdles for the sheepfolds are wearing low. So the farmer lops. The grim, individual shapes of the willow trees lean in a row over the black unfrozen waters of the running stream, seared and wrinkled, like a family of mourners. One by one the upspringing branches within

reach from the ladder are slashed off. The lopper next stands on the platform of the treetop, like an elongation of the dark tree itself, and chops at the few remaining branches until the last one towers alone and grotesque, like the single tooth in an old man's sunken mouth. This collapses, too, and the tree stands compact.

In the rickyard the root-hale, covered with earth and straw, is opened, and out of it tumble gleaming balls of purple and orange, their colour enriched by contrast with the dirty snow of the trodden ground. These are carted to the Big Barn and again tumbled out upon the dusty floor. Here in this shelter the men cut and slice the roots for the cattle, thankful to be away from the piercing wind on the fields. For there is no love of outdoor work just now. Eagerly the men search for those jobs that will keep them in shelter; the cowsheds are whitewashed, harness is mended and polished, traps and carts and waggons need repairing.

The days end early, and after feeding the animals in the stalls, the men go home down the lane, tripped up by the frozen ridges of the cart ruts, rosy in the setting sun. Hot meat teas await them, and long evenings of drawn curtains and pipes and dozing.

In the lofty elms of the vicarage garden the rooks, too, go home to rest, croaking loudly and solemnly as they settle into their bulgy nests in the treetops.

But the farmer sits throughout the long evenings in the farm kitchen, slowly and with many falterings, making out his plans for the year. There is no beginning and no end to this year of his, but the hard weather brings a pause. The oil lamp swings from the ceiling, casting giant shadows into the corners of the room. It throws a circle of light upon him and his notebook and stump of pencil that are to determine by a few scribbles on paper the face of the land through the year. By this stump of pencil is decided the fate of this calf and that sow, the rams over the hill, the bull in the barton. These badly-shaped grey letters will turn one field to grass and another to swedes, mate the grey mare, and fling the perfume of a beanfield across the land. They will form a nesting place for larks, and plough the field mouse from her home. The destiny of unhatched insects waits on the twist that red hand gives to his pencil. So is the pattern of the year designed out of the farmer's brain.

For days on end the steel grip of the frost holds the land. The plough lies half covered with snow; the robin hops in at the farm kitchen window. And all the time, under the coverlet of snow, the vivid green wheat grows in the fields. Soon the thaw will come, and as the dark earth is visible again in the farmhouse garden, it shall be spotted with snowdrops and the pale gold of frilled aconites.

MARCH *Threshing*

QUIET lies upon the fields and the woods this morning. No one is 'at plough', no one is carting. One might wonder what has happened but the familiar humming noise comes up from the rickyard, and skeins of black smoke are blurring the outlines of the leafless elms. Let us walk down to the farm, for surely this means that they are threshing.

As we come nearer, the humming noise is broken up into its parts; distinctly we hear the chug of the steam engine, the purr of the thresher and the clank of the elevator. These noises tell their tale of extreme activity long before we have turned the corner by the ash trees and can look down upon the rickyard.

It is a dull morning. The sky is a monotonous grey; there is no wind to give shapes to clouds: and well it is so, for any breeze would blow the dust of the threshing into eyes and throats unbearably. Even as it is, everything is dimmed and blurred by the grain dust. The rickyard is enveloped in a golden fawny mist. The men's clothes may be blue, green or brown, but today they all look the same dust colour. The red of the threshing machine is muted by the dust. The men's beards are full of it; the blue of the elevator is no clearer.

And now, through this film one perceives the actors in the game, each in his place, like players in an orchestra. On top of the half-demolished grain stack five figures stand out dark against the sky, pitchforks at all angles as they pierce the sheaves of wheat that have lain packed there since last August, and throw them over to Ted Birkett, the 'feeder', who is huddled and squat inside the top of the thresher itself. Ted Birkett is over seventy and has been a 'drasher', as he calls it, his whole life. He travels about everywhere with the threshing machine as it moves with the steam engine and the engine man from farm to farm over the countryside; he is as much an attachment as if he were part of the machinery itself. With a rapid mechanical movement he cuts the binding straw of each sheaf as it is thrown to him, and liberates the wheat into the quivering, shaking maw of the thresher. He is a grumpy old man and has to be humoured by the entire threshing party. At the far end of the thresher, the machine throws out the straw, which rides up the elevator to the stack. Here pitchforks again seize it and spread it out flat on the ever-increasing straw stack.

All this time sacks are fastened to the thresher for the grain and rapidly these gaunt, flabby shapes fill and swell and solidify. Everything and everyone moves. Let any one figure cease for a moment and the link in the chain snaps. Nothing is still. The steam engine shakes as it belches out its black smoke, while its tight-flung belting moves round the cog of the thresher; the threshing machine incessantly quivers and throbs like a person in a state of great emotion, as it consumes and discharges its winnowed grain; men remove and weigh the full sacks and hoist them across shoulders and take them up tiny wooden steps to the granary, like figures in the background of a Dürer print.

A dog, chained to its kennel in the yard, wriggles unceasingly with excitement. Are there mice and rats tumbling down from the disturbed grain stack? On the stack itself is an agitated terrier, dodging the pitchforks of the men as it rootles among the straw; the farmer's children are up there, too, with sticks, beating the stack to unearth the vermin. A mouse jumps over the edge of the stack and tumbles down the ladder. The dog in the kennel barks; the terrier whines. Life is surely worth living today, for man and dog and engine alike.

So this chain of labour runs on, hour after hour, grain stack shrinking in size, straw stack swelling, the elevator raised higher and higher.

On this March day dusk comes early, for the days are still short. The sky grows leaden in colour and the men on the ricks show up blurred against it. There is a flagging among the men. Dust has filled their noses and their throats; their muscles are tired. The grain stack is levelled to the ground. The straw stack towers above all else, loose and high. Jack is heard to grumble that he thinks he has done enough for one day.

'Seventy-four sacks I've gone and carried, I have—seventy-four; and full, too, every one of them.'

Ted Birkett thinks it is time he knocked off work, too. It is he who insists on setting the pace. The engine is stopped; the smoke vanishes and gradually the chug of the engine and the purr of the thrasher grow slower and fainter, till the machines seem like large, heavy animals falling asleep. Ted clambers doddering down the ladder, shaken by the diminishing tremors of the nodding thresher. His loose corduroy trousers flap as he climbs down, and he lands on the ground of the rickyard as the elevator chain gives its last heaving clank. In the sudden silence he shakes off the dust, and wipes his bowler hat with straw from the ground. It is a historic hat, worn by him each day for the past thirty years and cared for lovingly.

And now the rest of them slow down and stop. The ladder against the high straw stack trembles as the men step down it, pitchfork in hand. The top of the threshing machine is closed and a tarpaulin is spread over it. Soon everything is quiet, and the murmur of the men's voices grows fainter as they disperse to their homes for the night.

But the gleaners have ventured into the rickyard. Three farmyard cats, kings now of their own domain, slink around, hunting for mice that have managed to escape earlier in the day from the dogs; on the circular carpet of brushwood that is all that remains of the morning's grain stack, the farmyard fowls are busy, pecking at the wheat that has tumbled from the straw. What a scratching and fluttering there is in that small space.

Soon everything is quiet in the rickyard and even the hard shapes of the threshing machine and the engine grow softened and indistinct and withdraw into the dark of the night sky.

March is an unfriendly month, windy and rough and wet, with tantalising gleams of spring sunshine that encourage the little flowers in the coppice, only to let them be cruelly nipped by frosts. The fields are too wet for the plough and in this pause the farmer decides to thresh his remaining ricks. For several days now the air all around will be filled with the whirring, humming sound of the threshing machine. The ricks in the yard will have changed places as though a giant had been at play and had shifted them about. There is something eternal in this sound of threshing, even though it be made by machinery; it recalls the primeval songs of the women in the small islands of the Mediterranean as they chant in their strange Lydian mode to the horses and mules trotting round and round, blindfold, on a circle of sheaves, as they tread out the grain with their hoofs. For all sounds of the labours on the land date from the beginning of time.

APRIL *Sowing*

PRING is here with us. In little wafts it touches the trees and the hedges, giving us a feeling of certainty that it is here for always and that we have left behind us the cold and wet of winter; but it is fickle, and back upon us come the rains and the winds, the sleet and the frost. These little wafts of spring are worth a high price, and an hour of April sunshine will make us forget the bleakness of 'blackthorn winter', the inevitable period of cold and wind that the villagers expect while the blackthorn blossoms like snow upon the hedgerows.

April is a month of opening out and the start of swelling. The ground is well broken by the March frosts and the sun begins to warm the earth that is still cold and unfriendly.

The meadows by the river are in flood, the thaw has over-brimmed the river banks. On the farm, ditches are being cleared so the water can run away, and the land is hurriedly drained. There is much to do these days, for April pastures are still thin and the cows are not yet out to grass; and last year's hayricks are getting low.

On the Higher Farm they are still lambing. The mud sucks the baby lambs down into itself as they try to gambol and leap; it is a muddy month and the earth is still heavy.

The farmer watches this earth. There is sowing still to be done, but better a late sowing and a dry one than an early one now while the ploughlands are sticky with recent rains. Still the rains fall, until we begin to wonder if the sunshine is ever coming to us. The old and wise people of the village shake their heads and point to the still blossoming fling of snow on the thorns; there will be no sun until this has vanished. And the old story seems true.

But soon there comes a dancing day of light and warmth. Spring now is surely here. Lambs leap in the sunlit meadows and birds call loudly through the day until nightfall. Bloom is upon the plum tree, and gardens and woods and fields sing with flowers. The lanes are studded with them in their enamelled brightness: spurge and violet, celandine and primrose. We tread the earth as though it were the flowering mead of an early Italian painting. The children have felt the lift of spring. The woods echo to their shouts as they go primrosing; and the small paths to the village are strewn with fading flowers, dropped from tiny greedy hands that have picked more than they could hold. For who, on a day like this, with the sky a clear blue and full of birds' song, could resist a sulphur-carpeted wood, smelling of damp earth and spring?

The hillsides foam now with wild cherry, tossing and bowing and dancing in the soft wind. Cottage gardens beam with daffodils and hyacinths and the meadows are gilded with kingcups.

Everywhere there is abandonment and extravagance, and it is with this same rush of giving in his blood that the sower goes forth to sow.

In these days of machinery, where even on the smallest farms the driller is generally used, it is rare to see hand sowing. A few more years and it will have passed irrecoverably into history; but here and there a farmer remains who still feels some warmth come up to him from the earth as he strides his fields, and to whom the land is a matter of emotion as well as of economics. Here, in this country of little hills, the farmer still sows by hand.

With a lift in his tread he walks the ploughland that has already been harrowed of stones and weeds. A hopper of seed is strapped on his chest and, with a rhythmic movement of the right hand, he flings

the seed out upon the earth before him, a figure of generosity. It is the simplest, most spontaneous gesture imaginable, but on the exactness of his fling depends the farmer's crop for this year. Should he not use the exact strength of swing his seed will not be spread evenly; should he not loosen the grip of his fingers upon the seed in the right order, again his crop will grow patchily. He walks the field a god, flinging his bounties upon the world.

Behind the sower follows the harrow, covering over the seed so that the birds in the air may not devour it. But already there is a whirring of wings, and when the sower is at one end of the field, birds flutter over the earth at the other.

Spring glows in the farmer's heart as he strides. The cuckoo calls across the field and the elm trees are growing blurry at their edges. He thinks of his farm and of all the leaping young things that abound. Bleats of young lambs sound in his ears, and before his eyes come pictures of his foals and calves. He smiles as he recollects the broody brown hens in the yard.

And then he thinks of his wife, and a slight shadow passes across his face, like the shadow of a small white cloud over the sun. For he feels he has lost romance. He remembers her as she had been when he courted her; she was soft to kiss, with warm white limbs. There was a dimple just above her elbow, like a dip in a field; and her hair was brown and thick to hide in, like the soft bed of beech leaves in the woods in the autumn. Mechanically he strides his fields and flings his seed, a smile glowing on his face. And when the ploughman crosses him with the harrow he does not see him.

At the farmhouse the farmer's wife feels the same urgency of spring. She flits over the yard, feeding hens and pigs, scouring drinking troughs or hanging out linen. A blackbird sings on the budding lilac tree by the gate. Down in the orchard their child swings under blossoming pear trees. She smiles as she thinks of her husband and remembers the days when he courted her. His arms were strong, tight-muscled and warm, and he used to say she was as white-limbed as an open hazelnut.

She rushes up to her bedroom and gazes at herself in the glass, patting her hair and smoothing her bodice. Blush follows blush upon her face as thoughts hurry across her mind. Suddenly, without knowing why she does it, she finds she is changing her dress. She stares at her workday bodice, lying soiled and crumpled on a chair back, and passes her hand over the softness of her Sunday gown.

The farmer comes in at the gate, for it is dinner time.

'Jenny!' he shouts. 'Jenny! Where are you? See what I've got!'

He is hot and breathless as she runs to him. In his hands are flowers that he spills upon her, as it were seed upon the earth.

'Jenny!' he cries again as he kisses her. 'Jenny!'

They look at each other ashamed, and laugh.

MAY *Sheep Shearing*

OW it is warm in earth and air. Spilt are the fertile rains of April, and May is among the trees as they quicken and swell. The wastes of sky diminish between their branches; the meadows are growing lush and high, and the pathways in the little lanes have shrunk in width, so generously have the green things grown in the ditches. In the depth of the hedges, above the mist of cow parsley, many small bright eyes watch the lanes, fearful of men and boys; for nests are full of fledglings and a few late eggs, and mother birds remember.

But it is not only the leaves and the grasses that grow and quicken. All around the farmyard run tiny yellow balls of chickens, terrifying their penned mothers as they flutter about among the feet of the farm horses. One week more and these chickens will have lost their minuteness and they will know fear. So, too, in the meadows the lambs grow, and, as they grow, so do they learn sedateness, and gambol and frisk no more. Here and there a middle-aged lamb will forget itself and plunge rapturously at its mother for nourishment, but the irresponsibility of April is past.

This same thickening process of May extends to the sheep. Their wool grows burdensome, and with the first day of hot sun the heavy bodies pant under the weight of fleece.

This, surely, should be the time for the sheep shearing. But the shepherd is wise. He knows his England. The nightingale may sing in the oaks night and day, and the buttercup fields blaze golden in the sun; but still there will be wind and cold rain and many nights to come may silver the meadows with frost.

May is two-faced to poet and shepherd.

But a day comes when Abe Castle, the shepherd, feels sure. The blue sky is full of the white curled clouds that village children call 'Judges' Wigs'. The air is warm and soft. There is a great bustle on the farm, and in the big field beyond the lower lane they have put up hurdles. The grass of the field is high, and the sheep in their thick wool float upon this sea of grass like full-rigged barques. The wind ripples the grass into waves.

'A fine spell,' mutters Abe Castle. And well it needs to be, for it will be several days before the flock of sheep studding the field can be finished, though the shearers start early and work on until the dusk is so deep that they can barely see their shears.

This is a small farm among the hills and the shearing is still done by hand. The shepherd has arrived early, with Jack the shepherd boy and Floss the sheepdog. The shepherd's hut already stands in the meadow, custodian of the shears and the ointment against the slipping of the shears, and the tar for the marking of the shorn sheep. Floss feels irresponsible and delights in driving the sheep in eddying currents with her barking. This is her third year of shearing and with the sure instinct of the sheepdog she knows what is about to happen.

And now Jack is opening the larger hurdles and into it are driven a bevy of sheep, Floss close upon their heels. What a baa-ing and bleating. How bewildered the lambs are when they are kept from their dams. What confusion there is everywhere.

The little farm cart comes across the meadow, the horse wading through the tall grasses. Here are two more shearers, a boy to catch the sheep and a man to wind the fleeces. They spread tarpaulins on the ground, flattening out the grass and weighting their shearing mats at the corners with large stones. Off come coats

and waistcoats in the glow of the warm air. Sleeves are rolled up and shirts opened at the throat. The sun catches the grey hairs on the shepherd's chest; so might have looked a patriarch of the Old Testament, loose-robed among his flock.

Jack opens the hurdles of the catching pen and into it from the large pen is driven the first consignment of bleating victims. Outside the hurdles the dazed lambs group themselves, crying for their mothers.

The ceremony begins. The three men are ready, shears in hand. The first sheep is seized by the boy and dragged by her hind leg from the catching pen with the Shepherd's crook; that crook's shape has survived since Ancient Egypt, where Osiris tended his flocks of blessed souls in the afterlife.

Abe Castle grips the struggling, bewildered animal, and with a turn of the wrist throws her down on her haunches on the tarpaulin mat. He holds her firmly with his legs as he cuts away the locks from about her head and neck. They hang down ragged, until she looks like a frumpish old lady in a feather boa. The shears open the fleece on her chest and soon expose an expanse of skin that turns the white of her own lamb to a dirty grey. Her head is now held tightly between the shepherd's legs; her limbs stick out in front of her. She looks undignified and, surely, is aware of it, for she wriggles with shame and reproach. No dame should be treated with such effrontery. The sun throws the shadow of the shepherd across her white chest, accentuating the contours of her form, and glints on the shears in a score of stars.

This pink-flushed whiteness creeps down her body, first to her right and then to her left. The fleece falls from her flanks, all round her, crumpled and billowy, like the skirts of a ballerina, leaving exposed her tight, delicate limbs.

The shepherd now flings her over and leans his knee upon her. The quivering, panting creature grows more and more helpless, and terror looks out from her eyes; for she is a shearling and this has never before happened in her world. The shadow of this great man unbalances her. With the old sheep and the two-shear ewes some vague memories stir in their brains, and after a defiant struggle they will often resign themselves to the inevitable.

The shearers work on silently; they would have difficulty in making themselves heard above the bleating. The shepherd's shearling is nearly finished; a few more snips and she will be completely severed from her old self. Jack stands by with tar brush and pot and marks the farmer's initials on her beautiful white back. She struggles, and this time to her amazement finds herself free. But what has happened? There is such lightness, such elevation, such coolness. Dazed, she looks down at her discarded skirts as a dragonfly might gaze at the drab cocoon from which it had emerged, and with uncontrollable joy leaps out and away. But she is quick to adjust herself and before the shepherd has had time to raise himself and stretch his back, she is unconcernedly nibbling grass. By the time her lamb has discovered her and sniffed at her in wonderment, she has forgotten all about the shearing.

There lies her sloughed skin, thick and solid, light of colour within, curling into grey shadow on the outside; a curdled 'Judge's Wig' that has fallen to earth. A man removes it from the shepherd's shearing mat and kneeling on one knee twists it and binds it and tosses it aside to be the nucleus of a mound of white that will grow throughout the day.

So the chain of work runs on, half an hour to each sheep, one sheep to each man, and the meadow is studded with more and more shining silver bodies.

May is a white month. Sheared sheep and daisies in the meadows, chestnut candles and hawthorn snow in the hedgerows, white of

blossom in the orchards. White clouds toss and float across the sky, and white clothes blow on the washing line in cottage gardens.

 The sheep shearing songs are silent these days, dead with the harvest suppers and the gangs of mowers. On most farms the shearing itself is no longer done by hand and the shepherd's smock has vanished. But the beauty of a May evening of sheep shearing remains, when dusk closes down the distance like a mist and the sheep look lilac against the grasses. And still there is drama in the leap of a sheep as it is released from the hold of the shepherd and stands dazed and naked in its whiteness and grace.

JUNE *Haymaking*

'TIMES bain't what they was,' mumbles Andrew Girdler.

On a wooden seat outside the Seven Stars sit five old men. They are very, very old, and as the amber in their mugs of beer grows lower, they fling their minds into the past and search its treasury.

The chestnut tree in front casts a deep shadow on them. Beyond the sharp outline of this purple-blue shade the June sun glares down. Hens cluster, seeking coolness at the roots of the tree, and the three dogs belonging to the five old men are hunting in their sleep, as they lie stretched out beside their masters.

Andrew Girdler holds the ground. The four slightly less old men listen, their knobbly hands resting on the top of their sticks like pink toads.

'I mind me of the time when we lads went about in a mowing gang fifteen strong, I do. Like an army in the field we advanced, level and sure. But slow! Oh, ay, yes, slow and beautiful. I mind me of the way we kept in line, and if one of we lads lost his stroke he had to pay the next man a quart of beer, if he caught in his scythe, he did. I reckon there be nothing on earth so beautiful like as the swish of a scythe.'

Old Girdler shakes his head. Ted Lawrence, wizened like a pollard willow tree in winter, goes one further.

'I mind me o' when I were with Farmer Burdon. It were his barley and not the hay. We went mowing that barley twenty strong, we did. And so regular like we were that 'twas like one tremenjous regiment from one end o' Farmer Burdon's barley field to t'other. That were the days of haysel, that were. Yes, real haysel. Why, nowadays folks don't hardly know what the word haysel do mean. Why, would you believe it, young Jarge Withers said to me the other day, he did: "Haysel? What you meaning by haysel, Mr Edward Lawrence?" "Well," I sez, "seeing the way you do things these times, maybe you're right to call it summat else. Haymaking, then, if that should please you better, sir."'

Andrew Girdler shakes his head again. It is time he gets a word or two in.

'And what I say is,' he interrupts, 'there be nothing more beautiful than to see we lads as were, early in the morning, going to work with they scythes on our shoulders.'

A mechanical rasping noise floats to them across the blaze of sunlight. The five old men look at each other. They know that they are defeated.

Tom Cordrey squeaks out with his high-pitched voice.

'There they be at it already. As soon as this fine weather be fixed they do fetch out the cutter and the horse rake and the elevator and all. What did the Lord God Almighty mean when he did give us hands and arms to work with, but to use them?'

The amber has been drained from the mugs of beer, and as noon approaches the chestnut tree withdraws its shadow like a snail shrinking into its shell. The sun laps at the old men's feet, creeping slowly up their gaitered legs as they talk. Soon they grow conscious of the heat.

'Well, well, I must be going,' says each of the five old men in turn. They hobble off, vanquished by the sun but defiant still about the cutter.

Hay harvest has started.

The hayfields stand solid and thick, waist-high, a tawny glow

on them; so solid do they look, that one gives a little gasp of surprise when the breeze shivers them, or when a rabbit breaks into them. The weather has settled and the farmer must seize every fair day. Since early in the morning the noise of the cutter has been heard from the hayfields, and line after line of multicoloured grass has been laid low; pink, fawn, yellow and grey-green, rust-red of sorrel, white of moon daisy, tossing grasses, quaking, trembling grasses, erect, stiff grasses; all of them to become shapeless and colourless as hay. And as they fall to the cutter they carry down with them on their countless stalks miniature insects, more various even than the grasses themselves. For a hayfield teems with little things; voles and small mice, beetles and ants. A blue mist of dragonflies rises in front of the cutter. A lark fears for her home among the grasses.

With evening there comes a quietness in the hayfield, for no upright grasses still stand to rustle in the breeze. The white shirts of the mowers turn pink under the setting sun, and the crocus glow of the sky promises continuity of rainless days and nights.

Day after day this stillness creeps upon more and more of the meadows, as the swaying, animate grasses are laid low. From the clump of oast houses on the ridge one can look down on to a rapidly changing pattern of landscape, varying according to the stages of the haymaking. The first field that was cut is now dotted with an all-over design of large silver-green dumplings; for the hay there has been tossed and turned, ridged and cocked. Five Acre Meadow lies in straight lines of turned hay, the bulk of the ridges of grass making parallel strips of shadow, as evening lowers the sun's light.

Andrew Girdler and the rest of the village gaffers may fret and worry over the beauty that is past, but lenient time has still left much to us; rakes and pitchforks, and old, slim-bodied farm waggons painted blue. In the meadows by the stream, haymaking is in full swing. A truer pastoral it were hard to imagine. The whole village, it would seem, is out tossing the hay; some of the women even wearing print sunbonnets. The long wooden rakes endure, and no modern machinery can injure or hinder the gambols of the small children as they play hide and seek under the haycocks.

Above the voices in the hayfield sounds the endless purr of the elevator in the rickyard; down the lane the crunching hay wains pass and repass. The elms are now so thick that the men must lean low in the empty waggons to avoid the overhanging boughs. The full wains that return leave the hedges and trees streaked with wisps of hay.

In the fields where they carry the hay every cart on the farm is in use. Strange fortifications of wood and rope are put up all round the smaller carts, to keep the hay from falling out.

On into the late dusk purrs the elevator. Swallows skim the surface of the half-made hayricks, busy in the eaves of the barns. The elder flowers in the rickyard hedge gleam white in the gloom, their strong sweet smell rivalling the scent of the new made hay.

Rick after rick rises up into the yard, brushwood at base, sides sloping outwards against the rain. Waggon after waggon lurches along to the elevator; pitchforks move endlessly.

But the farmer sees clouds gathering in the west, and the ricks are not yet covered. Hastily posts are erected and emerald-green tarpaulins strung across the tops of the stacks, to be unfurled when the men stop work for the night, or the first raindrops fall. Beautiful do they look, these stretches of pale emerald, close against ultramarine of farm waggon and Indian-red of elevator.

The haysel kindles Andrew Girdler's blood. Instinctively, unintentionally, his feet take him to the lane below Five Acre Meadow. The last load will pass this way. He leans against the dusk-greyed

railings of the ford and listens. Soon he hears the creaking sound of the heavy waggon. The farmer's boy leads the horse until he reaches old Girdler, and with a swing he is on the horse's back as they cross the ford. The horse splashes and stumbles in the primrose waters. A wet trail of waggon wheel runs away from old Andrew's eyes up the dry lane. The purring of the distant elevator is hidden from his ears by the louder crunch and creak of the waggon.

'Now that be what I calls haysel,' murmurs Andrew Girdler. 'A horse, a waggon and a man. None of they machines. Yes that be real haysel'.

JULY *Cottage Gardens*

PAUSING, the year suspends its drama. The hayfields are empty and silent; the yellow-grey of stubble sinks already below the rising green of the after-grass: for summer thunderstorms have watered the meadows.

July is a time of little events, many and intimate, hidden under the quiet routine of village days. Life tastes good to the cottager this month. The sense of surprise may have gone from it, even as maturity lacks the unexpectedness of youth, and the harvest waits its moment. But there are little heralding harvests that show the way to the fullness of the later year. Go through the village street at twilight when thatched roof and lean-to are blurred against the silver sky. The cottage gardens are dotted with squat, headless ghosts, white against the dusk. Lean over the fence and peer closely and you will see no phantoms, but harmless, old lace curtains swathed round ripening fruit bushes, against the ravagings of birds. For the soft fruit harvest has come again.

Throughout the long evenings of July, the village women bend low in their gardens over raspberry cane and currant bush, gooseberry and loganberry. Time after time, baskets of shining fruit, purple currants and red and yellow gooseberry globes are taken into the gloom of cottage kitchens.

As the women pick the fruit, the men are busy with the vegetables. In this pause between haysel and harvest, when the work on the farm ends at its stated moment of the day, leaving the men free during the summer evenings, it is the gardeners' chance. Tenderly they care for their rule-straight rows of vegetables, staking the swelling peas and beans, watering, hoeing and weeding. Allotments gleam with lines of pale green salads, contrasted with tossing plumes of darker carrot tops; the pods of peas range up and down their staked plants like crotchets on a page of written music. Soon will come the time for the annual Village Show, when the pick of the vegetable gardens for miles around will lie in state, washed and trimmed, under marquees in the Rectory Meadow, and lucky bunches of giant onions or clumps of scrubbed potatoes will proudly bear the blue card of First Prize.

The men work into the night; the sound of the hoe comes from the cabbage patch when it is so dark that nothing shows but the white of the lilies and pinks and the ducks asleep by the pond.

But it is not only the fruit and the vegetables that call just now.

The cottage flower garden is the most essentially English thing of our countryside, and this month it flames with blossoms. Bees tumble among the rainbow colours of the herbaceous borders and roses smother cottage porches and darken casement windows. This love of flowers is so strong, that in his cabbage patch the farm labourer will sacrifice some of the limited space to them, and splashes of blue and crimson bloom among onions and beans. Even the village railway station glows with flowers, and the old stationmaster hoes between his rose bushes as he awaits the arrival of the uptrain to London.

It is summer's turning point and everything is full and lush, be it rush of flowers in the gardens or fling of convolvulus over the hedges in the lane, or the milky stream of meadowsweet in the ditches.

The sunny days are hot and heavy with the sound of bees. As the ploughboy goes for his beer at midday to the Black Swan, he pauses and loiters under the bee-covered, flowering lime trees, inarticulately wondering at this beauty of scent and sound. The

lanes are full of fledglings that as yet know no fear, while the air is broken by young swallows learning to fly.

But in contrast to all this swift movement of young life, there are the hoers. Six in a line they stand, backs bent in the heat, weeding the rows of swedes in the root fields. Their movements across the field seem so slow as to be hardly perceptible. Six hoes go out at the same angle to weed and thin among the roots; six identical twists of the tool lift the weeds; six pairs of legs move slowly forward. Hour on hour these figures work without word or divergence. The air above them quivers in the heat.

Through the afternoon the cows laze in the sloping meadows. But now it is milking time. They sleepily turn their heads as they hear the cowman lift the latch of the gate. He calls to them across the field.

'Frump; Daisy and Moth; Flossy and Snowdrop; Dapple.'

They swing themselves round like heavy ships and move in orderly line across the meadow. Slowly they saunter over the dry caked mud of the farmyard and each cow goes to her ordained place in the coolness of the whitewashed cowshed. The udders are full and heavy, and the cows are unstinting as they give themselves to the milkers. The men sit on the three-legged stools, peaks of caps turned to the nape of their necks, resting their heads against the hot flanks of the cows. Gently and firmly they pull at the udders and with a light, squirting noise the milk falls into the pail, foaming with the impact. Soon the cows are all milked, and quietly the orderly line moves out again into the westering sun—Bess and Queenie, Dapple and Snowdrop.

As the month goes on to its close, there is a feeling that the stage is being set for the drama of the harvest. The faint scent of wheat in flower is perceptible no longer, and the fields of grain stand high and firm. The oats are turning silver and there is a warm flush on the wheat.

But there is still time to pause and dally, and on these lengthy summer evenings the youth of the village is free. The lanes are heavy and secret for courting, and as the farm lads walk out with their girls in the long shadowed light, the leafage bends low to hide them. Their murmuring is broken by shouts from the village green, where the local cricket team is playing a neighbouring village. Under the bordering elms the old men sit to watch the game.

The evening air grows cooler. Outside their cottage doors sit the aged people. In the dusk their white aprons and white shirtsleeves show in the gardens like clumps of white blossom. Silently they sit, hour after hour, with tired hands at rest on their laps and eyes looking quietly around them at the swallows nesting in their thatch, or the cat asleep under the roses, or the gold in the sky.

Night falls upon the village very gently.

AUGUST *Harvesting*

SUMMER begins to tire. Dust greys the leaves of the hedges, that are already brown-rimmed and frayed by insects. The elms are at their heaviest; over in the plain they are so dark that one would call them indigo rather than green. They have lost their fresh colour and their alert foliage. The clumps of elms by the old cowshed lean their branches downwards in sorrowful fatigue; for the days are sultry and windless and all green things flag.

On this hot afternoon of August the new hay gives out a smell of sickly sweetness, and in the rickyard, where large open spaces promise a rich harvest, all is very quiet. The little brown hens huddle into nests of dust, and croon in the heat. The cattle are away in the pastures, under the shade of trees, unsuccessfully flicking off the flies that pester their ears and their eyes. At the corner of the lane the pond has shrunk and stands brown and still. No one stirs. The farmer's wife has drawn the blinds of the windows on the south side of the farmhouse lest the sun should fade her furnishings, and feet loiter comfortably on the coolness of the dairy's stone floor.

But the farmer walks abroad in the heat of the day. In the glaring sun and quivering air he studies his fields, watching the sky and the crops for signs. For the supreme moment of his year is upon him and harvesting is due.

Does the wind blow west? Is there storm coming? Does the straw break noisily in the heat? The farmer looks and sniffs and knows that it is time.

He climbs the hill. Below him roll the fields in their varying colours and shapes; here a fat, rounded field, there a series of narrow strips, some large and impersonal, others small and intimate, all of them busy with their own contribution to the year's harvest. His eye skims over his grazing land, green from recent rains and studded with russet cows, passes casually over the acrid-coloured fields of root crops, and comes to rest on the fields of grain. For it is of them that he is thinking. There to the right are his silver oats—the first that will fall to the cutter. Great slow-moving white clouds throw their shadows over his wheat fields, sunburnt to a bronzed orange. The cloud shadows pass and mute the colour of his barley, where its drooping heads sway in the breeze. Away and away into the plain they stretch, till his ancestral fields vanish into space. But everywhere in this vast sweep of landscape there is the golden glow of harvest, melting into the silver of distance.

The harvesting draws all men to it. Ploughboy and cowman, carter and shepherd, all are in the fields. Strange farmhands have appeared, too; vagrants tramping the countryside for work. These are gathered warmly into the fellowship of the harvesting, and no question asked. For the glamour of the sheaves blends all. The silvery, quaking oats are the first to fall. Round the edge of the field the men cut with sickle and crooked stick, making a pathway for the reaper and the team. These oats they tie into sheaves and lean them against the hedge, like garnishing round a dish.

The hum of the reaper is heard early on these relentlessly blazing days, while yet the air is fresh from the night and a slight breeze stirs. Round and round the ever-decreasing square of standing oats move the horses and reaper, slashing and laying low the grain, till the field looks like a massacred army.

On through the panting hours of heat tread the horses, their bodies heaving in the sun, their tails flicking off the pestering flies.

The farmer on the reaper tires and flags and is relieved by the carter. The men stooking the sheaves wilt in the glare. Their open shirts cling to their wet bodies; cabbage leaves beneath their hats keep their heads cool. They are too hot to eat. The sun burns down on them. 'Fine weather for harvesting,' says the farmer, flinging himself with the others into the scanty shade of a ditch. On and on they go, till the school children on holiday bring them jugs of tea, and the sun slants on them, golden and genial. The shadows of the stooks grow longer, eating up the space of stubble between the rows.

But inside the small square of standing grain there is tragedy, and little hearts are beating; all day the rabbits run inwards and still inwards, away from the tread of hoof and the slashing noise of the reaper. Now they can see the feet of the horses as they plod round and round. Wild terror fills their bodies. Yet they do not know that in the rough, unexpected nakedness of stubble outside wait boys and dogs and guns. Desperately they leap from the approaching hoofs and the shine of the reaper, to the slayers. There is a wriggle and then silence.

Into the late evening the men stook the sheaves. Six, eight or ten sheaves of wheat or barley to a stook, but fewer of oats, lest they should 'heat'. Here on this farm, ten sheaves of wheat is the number, but 'over in another country,' says the shepherd, 'six miles away, they do be stooking it with six.'

Rhythmically, gracefully, the men stoop to lift the sheaves, moving in the same way their sires had moved, with the exactitude born of economy. With the left leg flung out behind them, stooping, they move as figures in an ancient dance. And the prostrate sheaves come to life before one's eyes, hissing like spray as they are tilted against each other. They seem to cling together for comfort. As the golden evening wears itself out, the stooks stretch their purple arms of shadows across the stubble until they reach their neighbouring stooks and caressingly creep up their skirts. It is as though the harvest field of sheaves held hands, like frightened children in the dark.

The sun has set in clouds in the west, and the last short line of standing oats has been laid low. The gnats and other hot weather insects hum around, loud in ears tuned to the summer silence of birds, and alert since the whirring, clashing reaper suddenly stopped. Across in the plain, scarves of white mist lie heavily on the fields, sure sign of the approach of the Fall. Heavily the men trudge home, stumbling, the horses plod to the stables, and when the harvest moon has risen, it looks down upon an unmoving world, sodden with sleep.

But the farmer's work is only started. There is the big West Field to cut. Not a matter of one day's course of the sun, but three scorching noons and three dusks when the moths brush blindly across one's face and the shapes of the sheaves are felt rather than seen.

And so, day by day, the face of the country changes as it did a few months back with hay harvesting: tossing golden sea of wheat gives place to heraldic patterning of stooks, which in their turn disappear, leaving bare stubble and gleaning rooks. For with unbroken weather the farmer will cart as soon as his grain is dry. Pitchforks ravage the stooks, and the sheaves are flung into lumbering farm waggons. All day long the elevator in the rickyard whirrs as the waggons bring in the yield to be stacked. Along the lanes, where the overhanging boughs of the elm trees caught the wisps of hay in June, they now catch at the straw.

From the hill the farmer looks down upon an expanse of stubble field. The last load has been carried. In his cloistered yard stand nine golden ricks.

SEPTEMBER *Apple Picking*

IT is the month of ripeness—a golden, crimson and russet month. Here in Kent the orchards offer themselves to stage the drama of the year. Throughout the summer, when the fields around were alive with the sounds of haymaking and harvest, these miles of trees grew in silence, while the pale green of the swelling apples hid beneath the leaves. Since their pink and white foaming in May, no one has remarked them, except perhaps the mower as he cut the grass from around their feet, or the farmer as he has watched the apples setting. But now all that is changed. These calm golden days have brought ladders and shouting, the creaking of wheels and the thud off falling apples.

The gatherers come early, when the dew on the heavy grass and nettles wets their legs and bediamonds the leaves, and there is a mysterious gloom and depth of shadow along the aisles of trees.

A glow burns through the countryside at the thought of the apple gathering. 'They have started picking,' say the old people to each other down in the village. Something stirs in their blood, a memory of gatherings when the mistletoe was sacred, and prayer gave motion to the sun, and stones were still alive. So, too, do their hands and minds leap mountains and centuries, linking in pagan continuity with gods, grape-stained in their Mediterranean vineyards. It is one of the pinnacles in the rhythm of their year.

The army of ladders attacks the trees. On all sides, at all angles, are they reared, placed against unresisting branches and in the clefts of gnarled trunks—a veritable fugue in ladders. The old men with their baskets on a hook start picking the lower apples within reach of the safety of the ground; rheumaticky limbs are not so fond of climbing. But the youths leap the ladders, and systematically the pillage begins. The trees shake and tremble, the figures run up and down, emptying picking aprons, exchanging full for empty baskets; and the branches leap upwards, relieved of their weight of fruit.

And now the sun is high and each tree courteously spreads a circular dark green carpet of shade beneath itself. They stretch, these circles of shadow, back into the shapelessness of distance, narrowing into ellipses as they go.

At midday, as the sun beats down upon the browned arms of the pickers, the men step with relief into the shade. It is dinner time. Bottles of cold tea and beer are produced, and chunks of cheese and bread; and leaning against the trunks of the trees they sit, or sprawling in the shadow, they eat and talk. Old Tom Latimer has picked 'this seventy year'. He mumbles with his toothless jaw, comparing this tree with that, this year's yield with the one of thirty years back. He is himself like one of his own apples; red lacquer stains each cheek, wizened as an apple forgotten in the loft. As a shepherd knows each sheep in his flock, so is the intimate shape of each apple tree stamped upon Tom's mind. He shakes his head at the young men lazing, and is off up the ladders again.

So throughout the hot afternoon they pick, moving their ladders and baskets over the board of the orchard like counters in a game. And as the pickers move, they are followed by the clumps of men who sort the apples. Instinctively, mechanically, they select them, by weight and soundness, dealing them out into the right bushel baskets. Following the group of baskets, in their turn come the carts. There is a swishing sound as they brush the trees in passing. The horse tosses his head into the lower leaves of the trees, against the attacking flies. And so the fruit of the trees is taken away, to be covered

up and labelled and put into a railway siding, for grey-faced people in the cities who never saw an apple shine upon the top most bough against the blue of a September sky.

But what is that shouting away over the fields? What is that music of mouth organ and concertina? Beyond the trees and past the next slope ends another harvesting and the ravaged Kentish hop fields are lying back to rest. While still the apple trees bent beneath their fruit, these hop fields were half stripped. Poles were torn up, wreathed with the tendrilled hop plants, and laid against the canvas tally baskets, till they looked like the oars of an ancient galley. Here, for the picking, gather the outpourings of the London slums, in all their flimsy finery and their fear of rain, cumbered with babies and tin tea kettles. The fields must have shivered with the clamour. Girl shouted to girl across the avenues of hop poles; old woman quarrelled with old woman, till the feathers in their bonnets nodded drunkenly; sun-cheated children chased each other among the tally baskets; tired, white-faced men sighed from out their contentment as they counted the diminishing days before they should be sent back to the heaving heat of the London pavements. And over it all was the beauty of the hop plants, like a blessing.

But with cheers and shouting, concertinas and song, the last lorry load of pickers has left the hop fields, and the naked hop poles stand silent.

Over the country there is peace. The resting fields have given up their yield. Oast houses and rickyards and barns are full. In the cottage gardens the fruit has been picked, apple and pear, quince and plum. Go down the village street on a late September afternoon and the warm burnt smell of jam-making oozes out of open cottage doors. Soon the last apple will have been picked and the orchards will be silent again.

Sunday evening in the village church: the days are drawing in and the smelly gas lamps flicker unevenly with their greenish yellow light. It is Harvest Festival and the church is full. Farmer Stevens peeps behind him to look with a sense of possession at his sheaves of wheat around the font. Old Mrs Yeo is wondering where her orange dahlias have been put, and knows that the pink ones in the place of honour on the pulpit are not as good as hers. Rows of large apples line the chancel, red and yellow and green. The lectern is almost hidden in a tangle of oats. Obscurely at the back sits a ploughboy. He is shy and fidgets with his bow under the unaccustomed constriction of his Sunday collar. He has lost his way in the Service, for he never comes to church. But every year the Harvest Festival pulls him. He listens to the vicar preaching; he sees the squire and his lady in the front pew, and all the gentry smiling to each other. He feels lonely and untidy. Suddenly a flame of understanding consumes him. He is surrounded by a white light and God's hand is upon him. This is *his* service. It is about *him* that the vicar is preaching. He no longer fears the squire and his lady and all the gentry in the church. Those oats are his, and the wheat round the font. Who but he knew the fields before the plough had turned them? Was it not he who rose in the dark of winter mornings and with chilblained hands and numb feet fed the horses? Who else but he had withstood the March gales as he followed the plough? And now it is Harvest Festival. He strains forward to look at the apples, the oats and the wheat.

'Yes,' he tells himself. 'It is mine! All mine.'

To the ploughboy the meaning of gathering is revealed.

OCTOBER *Cider Making*

ROUND and round in a Devon barn plod two old men throughout the golden hours of an October day. Our eyes, accustomed to the bright sunshine outside, can at first see nothing in the deep shadow of the barn but vague shapes moving with regular tread to the sounds of creaks and wrenchings and clanks. Out of the background of these sounds comes a little trickling gurgle, like a running stream. As we grow used to the gloom, shapes solidify out of the dark of the barn. The light catches the screw of the enormous wooden cider press, its edges smoothed and softened by age. The same light sparkles upon the metal bands of the tubs. Shafts of gold dart through the walls of the barn at odd places, where the woodwork has decayed, picking out here the haft of a spade, there a pile of pressed apple pulp or a dust-filmed bottle.

Round and round trudge two old men, leaning heavily on the winch. The red Devon earth cakes their gaitered legs and smears their clothes. They are themselves mere upright pillars of this earth, and when they talk to each other, in unintelligible grunts, their speech has an earthy sound.

As hour after hour the winch turns the screw, the sacks of apple pulp flatten and diminish, and after a time the trickling gurgle of juice grows feeble and uncertain. Creaking and groaning, the press plays a sleepy bass to the grunts of the two old men and the shuffle of their earth-caked boots. Age is upon it all; we are outside of time. These men must have been trudging round and round before our grandsires were born; and they will be trudging still when we ourselves are dead. Only the shifting of the sunlight on the floor of the barn shows us that time has not paused. While we watch, the sun quits the metal band of one of the tubs and strokes the basket of unpulped apples by its side. In the blackness of the barn it catches at the wooden cogs of the enormous wheel that the donkey turns to crunch and pulp the apples, reducing their crimson and green and yellow variety to a uniform brown mass. Hens stray into the cider barn, each one bringing in front of her a little purple shadow. They peck at the apple pips among the men's feet. As the day goes on, the smell of the apple pulp grows sickly in its sweetness. Still the old men trudge.

Outside in the sunshine everything shimmers. Gold falls in splashes on the branches of the elm, and the beechwoods are turning a burnt brown. Scarlet berries spot the hedgerows, converting the red of the Devon earth to a dull crimson. Away on the open stretches of Dartmoor, the wind is already bleak and unfriendly and the ponies huddle for warmth at night under the stunted bushes; but here in this soft land of shelter, where, round and sudden as a child's imaginings, rise the little wooded hills, the autumn is still kind in its touch. It is gentle and golden, and if a few leaves have started to fall from the trees, it must have been by accident. There is as yet no hint of winter, for the film of frost upon the ricks vanishes when the sun rises. When it beats upon the hedgerows the dewdrops disappear from the spiders' webs that bind one curl of traveller's joy to the next.

The wood pigeons begin to haunt the lanes where the oak trees drop their harvest; their crops are swollen with acorns. The red squirrels prudently bury their store of nuts and acorns. The trees rustle as they leap and run. They look like flaming autumn leaves that have detached themselves from their branches. In the village

thin spires of smoke, of the colour of a blue Persian cat, rise vertically into the sky; for rakes and brooms are at work upon the refuse from cottage gardens, and bonfires bring with them the smell of the fall.

Through the sleepy glow of the October afternoon the two old men in the cider barn trudge round and round, grunting to each other from time to time. The sun has now swung over to the far end of the cider press and catches new forms and objects, leaving in shadow the cider barrels that earlier in the day it had emblazoned. A cat emerges from the shade, lazily stretches herself, and takes her seat in the path of the sun. Nothing else has changed.

Outside in the farmyard the sun has moved above the roof of the cowshed opposite and gilds the figure of the man thatching a rick. Over everything it throws soft edged shadows, lilac against the gold of the autumnal light.

In the fields the root crop is being harvested. We have grown accustomed throughout the summer months to their bitter acrid green, and as the men 'get off' the mangolds there is a dull, uniform look about the landscape that more than anything else tells of approaching winter. By the Lower Farm they are lifting beet. The men go down the ridges, drawing the roots from the soil. With the economy of movement that characterises all work on the land, they cut off the leafy tops of the beets as they stoop, and throw the roots in a line. The cart follows them, accompanied by two men who rapidly and rhythmically lift the beet with both hands and fling them into the cart. It looks like the first sketch of some old folk dance. Now the long autumn twilight falls; mists cling to the fields, and flaming sunsets fire the countryside, tree trunk and waggon, hayrick and ploughboy alike. The sun that in the summer evenings burnished the roof of the farmhouse as it set, halts now in the south and ends its dwindling path behind the village church.

Down the lane comes a crowd of school children. Purple-stained mouths and hands reveal that they have been blackberrying on the common. They hurry home in the darkening twilight.

Against the sunset sky the cider barn stands dark and dignified. The sun no longer blazes on metal and shiny surface; there is a brown mellowness reflected from the crocus glow outside.

The gloom emphasises the stateliness of the barn. It stands like an old cathedral; the leaping wooden beams in the high roof are its vaultings; the cider press its altar. The gloom deepens for its unhallowed vespers. Bats drop from its roof and rush with a shrill cry into the dusk.

Night falls on two old men, still trudging.

NOVEMBER *Ploughing*

GOLD of autumn fades from the earth and the picture this month is one of a chromatic scale of greys. The darkness of late dawn blends into the day without changing its key; the day harmoniously merges into the darkness of early night. But during these short hours snatched from the greed of night much must be done. The fields, tired after their labour of harvest, are allowed no rest. They must be ripped by the plough so the frosts of winter may break and crumble the clods. Over the countryside, silhouetted darkly against large, grey, windy skies, tramp the eternal figures of ploughman and team. They fret the long sweeping lines of field and hill, stirring within us a strong feeling of poetry and romance. For of all work on the land, ploughing is perhaps the most eternal and fills us always with the same rush of emotion; whether it be on the little fields of India where the peasant guides the identical dwarf instrument of wood that his prehistoric sires used, or the team-drawn iron plough that gently turns the sod of the rolling English downland, or the Gargantuan tractor that devours the acres of the American earth, all impress us with the sense of the right values in life.

Now the lanes are full of carts that carry the farmyard litter to the fields. The land is dotted with these dark piles of 'muck' that are to be spread over the earth, to feed it, before the plough shall turn it. The autumn mists hang heavy on the earth, submerging everything in a thick sea of white; above this inundation the treetops standout, stark and black. The warmth from the farmyard litter rises in steam and blends with this white sea. Voices of men call across the mist and dark shapes move over the fields, levelling the brown piles of manure. From the gate comes a clumping, stamping sound of horses' feet, mingled with the clank of brasses on collars and harness and the low grunts of the ploughman's horse-talk.

Ploughing is beginning.

Shaft-straight in the mist lies the first furrow of turned earth, a brown line stretched tight across the length of the field. The land is heavy and 'loving', and clings to the ploughman's boots as he lifts each foot from the ground; it clogs the hoofs of the four horses as they strain up the slope of the field against the weight of the earth; it hinders the plough itself.

The mist lifts, and now we can see the ploughman with his team and the ploughboy with his brass-studded whip. Dampness still stands on the ploughman's moustache in shining wet drops; but the drying air is cold and the breath comes from the horses like fog. The chocolate-coloured sods, sharp-edged because they have been but recently ploughed, glisten as though they had been polished. Over the field, shrill crying lapwings stagger and tumble; flocks of gleaming rooks follow the plough.

Firmly the ploughman holds the handles, taking care not to press too much or too little on them, lest the depth of his furrows should vary. Keenly he keeps his eye on the end of the furrow so his line may be straight, and turning his team and his plough at the field's edge, he must make the right curve lest it be too sharp and he get pitched into the ditch, or too wide and he miss the next furrow.

For ploughing is as hard as all the things that look so simple.

The horses toss their manes and nod their thick muscled necks as they walk. Their bodies gleam and shake as the weight is thrown first on one leg, then on another. The breeze stirs their bushy tails and blows the hair of their shaggy feet. Very stately and noble do

they look in the large, ever-changing design of their grouping. The ploughman grunts and talks to them in a strange tongue, but the horses understand this language and obey. Last season the ploughman hurt his foot and a stranger drove the team: but when he reached the field's edge the horses would not turn. He did not know their speech.

Brown creeps over the field as the ploughed land widens. From time to time the horses disturb a covey of partridges in the stubble. The birds rise into the air with a whirring of wings like the noise made in winding up a toy.

In strange contrast to the jet black of the following rooks, white seagulls dip around the horses; they have flown far inland from the distant sea and bring with them a salty smell and tidings of rain and storm.

The mist now has entirely vanished and the sky is large and filled with scurrying wind-blown clouds. From the distance comes the sound of a huntsman's horn and the baying of hounds for hunting is in full cry, and frightened panting foxes search for holes in the earth away from dogs and men.

Along the roads the hedges are being cleared and bonfires of burning refuse dot the roadside. Old men with hooks and leather gloves slash at the berried briar and bramble, trimming and destroying the undergrowth, layering the main branches of the hedgerows.

In the woods on the hilltops there is shaking and trembling among the trees; the woodmen are throwing beech trees. Ropes and axes and double saws work at the destruction of the proud, lofty trunks, gashing the smooth grey skin, without respect for age and dignity. With a shiver and an upward leap the huge bodies tumble, crushing saplings and undergrowth beneath their weight as they fall. The heavy crashing boom descends to the village below the hill.

Not very far off, in the deepest shade of the woods, a chair bodger sits in his primitive straw-covered hut, turning last year's felled beech trees into chair legs. Throughout the months he sits at his handmade lathe, among a sea of shavings; and without his hut the stacked piles of naked white chair legs grow bigger and bigger. Soon he will remove himself and his hut and his lathe to another part of the woods, and leaves will cover his place.

The huntsmen, too, invade the woods. Squawks of pheasants tear the air as sharp shots are heard. But the thick undergrowth is kind to the birds, and crimson and gold of late bramble leaf protect the gorgeous colouring of the cock pheasant.

And all the while the team is at plough. Brown spreads over the curving fields that creep up to the slopes of the hills. The dark figures of man and horse appear and disappear on the skyline as the land rises and dips. Always they move heavily and slowly, and always they seem to be a part of the earth they tread.

The short day closes. On the common the gipsies huddle into their caravans for the night. The poacher slinks off unobserved to the woods. In the village, lights appear in cottage windows, and, as the cottagers draw their curtains for the evening, they hear the sound of the team going home down the lane after plough. Four tired horses stumble along; on one of them sits a nodding ploughman, on another sits the ploughboy; the horses move with weighty tread and disappear into the dusk at the turn of the lane.

DECEMBER *The Fat Stock Market*

CHAOS this morning is upon all the little farms for miles around, for it is the day of the Annual Fat Stock Show. Farmers are abroad in the starlight, fixing chains and traces to their carts, or finally inspecting their animals. The women are up and about, in the dark, drawing in the laces of creaking stays, buttoning tight gowns and soaping shiny faces. From all these farms there rises a chorus of noise into the sky; cows moo, sheep bleat, cocks, hens and geese indulge in rowdy fluster as they are caught and put into crates. Over it all, like a veil, hangs the ceaseless drip of the rain.

For days past the minds of the farmers and their wives have been fixed on the Annual Fat Stock Show: it is the last triumphant event of the year, the consummation of months of labour. These have been days of deliberation, for on the farmer's decision depends his luck in the future. Should he sell Claribel? She is one of his best milkers; but he would get a good price for her. And that sow in farrow? What should he do? It is a worrying moment.

Upstairs in the bedroom, Mrs Plum dabs her eyes as she dresses. For Tom has said he must sell Daisy—Daisy, whom she had nursed through calving and the pneumonia and who would toss her pretty head and shake her dappled flanks and run across the meadow to you when you called. Mrs Plum struggles with her tears and tries to fix her mind on the bright side of things; there's that dress length she is going to get herself, and the stuff for the new curtains in the parlour. But be brave as she may, visions of Daisy obtrude themselves, and it is a red-eyed Mrs Plum who drives to market by her husband's side.

As the late dawn of winter lightens, most of the preparations are completed. The pigs are bundled into netted overcarts, the crates of ducks and geese are packed into vans. Already, an hour or two before dawn, the shepherd has started his long wet trudge to the market town with his sheep. Quick-stepping pony carts on the road pass heavy-uddered cows painfully sauntering along unmilked; for it is by the bulk of their udders and their yield of milk that they will sell.

All the roads and little lanes converging to the market town echo to the cloppeting of animals' feet, and the fringed branches of elm trees drip heavily upon the hats of the farmers and the umbrellas of their square-bosomed wives, as they sit tight and upright in trotting pony traps.

Now the little town prepares to receive this inpouring. Since dawn it has been busy. Cattle drovers have erected hurdles in the wide marketplace; the stalls have arrived, and under shelter of canvas awnings hang rows of stockings and men's neckties, winter undergarments and children's toys. The pedlars loiter about the open market square. The seller of hair tonic polishes his best phrases. In the Rising Sun the dinner is already in the ovens.

One by one the conveyances arrive: large motor vans, netted over milk floats, high dog carts, dilapidated motor cars; each carries its store of victims. Bleats and squeals, screams and moans fill the air of the market town as the animals' terror overcomes them. Fright sends them rushing blindly over the market square. Small boys with sticks beat back terrified pigs. A calf escapes into a baker's shop. Just as a flock of sheep is being successfully steered into the right pens there is an uproar; Farmer Clew's bull has broken loose. The women splash through the puddles to the shelter of the shops; the men wave their ash sticks in the air. But the bull is caught, and soon the little town grows quieter as the pens are filled with frightened-eyed animals.

And now the farmers make the round of the pens, poking with their sticks at the bodies of the animals. As the morning goes on, the crowd thickens, and among it can be seen the oddest creatures imaginable, with their old black coats greened by the sun of a score of summers. Here we see the strangest neckwear and headgear, the most obsolete forms of headdressing. Old men with beards encircling their faces from ear round to ear, and big check capes, sit for hours on end upon the hurdles, resting their horny hands on their sticks and gossiping about the animals. Old George Gibbings is eighty and has not missed the weekly market for sixty years.

But today is not the ordinary weekly market. It is the summit of the year. A hush creeps over the crowds as the judges are seen to move among the pens, poking this pig's back, feeling that sheep's rain-sodden wool or trying the udders of a cow. There is an intake of breath as the red rosette is pinned to the pen of the prize pig.

The hush is broken by the ringing of the auctioneer's handbell. There is a rush to follow him, and a clump of bidders surrounds him. High up on a wooden box he stands, as his hammer decides the destiny of each animal. The clump moves with him from pen to pen and settles round the pinnacled auctioneer.

The selling is over. Velvet-eyed calves have been doomed to separation from their mothers, the shadow of the slaughterhouse is thrown already upon the large pink pigs.

The landlord of the Rising Sun stands in the shelter of his doorway. It is now his moment. Already groups of farmers splash their way across the puddled cobbles to the inn, and soon the beer will flow, and knives and forks will join with loud talking and laughter, to make of the Rising Sun a pandemonium of noise.

And the farmers' wives? They meet for their dinner in a teashop, gossiping and joking as loudly as their husbands. For life is bright to them, too. Has not the pig been well sold? And have not the cows brought in more than had been expected? Lumbered with their parcels of woollen stockings and cough mixture, currants for the Christmas pudding and stuff for the parlour curtains, they gurgle over their tea and ham. But Mrs Plum is still red-eyed and sad. Daisy has been sold. 'Tom would do it,' she murmurs to herself. 'He would do it. But I know he'll rue it. He'll miss her sore.'

The winter sun is breaking through the rain clouds and showing yellow and low in the west. The farmers look at their watches. The carriers have baited their horses and are receiving bundlesome old bodies with parcels, flushed from the day's excitement and eager to get the best seats. The rain has stopped, but the dripping umbrellas make pools on the floor of the carriers' vans. Several of the stalls have lit their flares, and the vendors of patent medicines are flinging themselves into a final eloquence as they see the homeward look in people's eyes. Far up the street comes the tiny blast of a trumpet playing a Christmas carol. The shops now are lighting up. Long twisty rivers of yellow are reflected across the wet market square. Ponies are harnessed to dog carts. Wives and bundles are collected, and as the sun sets in a pale streak on the horizon, the marketplace empties.

Along the lanes, splashing through the puddles, go the vans and the pony carts, the milk floats and the dilapidated motor cars. Out into the quietness and darkness they vanish, radiating from the centre of the market town to the four corners of the neighbouring country. Soon the sounds are gathered into the shelter of isolated, remote farmhouses and the roads have peace.

Mrs Plum sits beside her Tom. She snivels. Tom looks round. 'Martha, if tha' can't keep that noise to tha' self,' he mutters. 'As if I didn't get a good price for Daisy.' But Tom's own mouth quivers.

All the following week the butchers' shops are gay with the rosetted bodies of animals. But they are silent now.

Little Toller Books

We publish old and new writing attuned to nature and the landscape, working with a wide range of the very best writers and artists. We pride ourselves on publishing affordable books of the highest quality. If you have enjoyed this book, you will also like exploring our other titles.

Anthology
ARBOREAL: WOODLAND WORDS
CORNERSTONES: SUBTERRANEAN WRITING

Field Notes
MY HOME IS THE SKY: THE LIFE OF J. A. BAKER *Hetty Saunders*
DEER ISLAND *Neil Ansell*
ORISON FOR A CURLEW *Horatio Clare*
SOMETHING OF HIS ART: WALKING WITH J. S. BACH *Horatio Clare*
LOVE, MADNESS, FISHING *Dexter Petley*
WATER AND SKY *Neil Sentance*
THE TREE *John Fowles*

New Nature Monographs
HERBACEOUS *Paul Evans*
ON SILBURY HILL *Adam Thorpe*
THE ASH TREE *Oliver Rackham*
MERMAIDS *Sophia Kingshill*
BLACK APPLES OF GOWER *Iain Sinclair*
BEYOND THE FELL WALL *Richard Skelton*
LIMESTONE COUNTRY *Fiona Sampson*
HAVERGEY *John Burnside*
SNOW *Marcus Sedgwick*
LANDFILL *Tim Dee*
SPIRITS OF PLACE *Sara Maitland*

Nature Classics Library
THROUGH THE WOODS *H. E. Bates*
MEN AND THE FIELDS *Adrian Bell*
THE MIRROR OF THE SEA *Joseph Conrad*
ISLAND YEARS, ISLAND FARM *Frank Fraser Darling*
THE MAKING OF THE ENGLISH LANDSCAPE *W. G. Hoskins*
BROTHER TO THE OX *Fred Kitchen*
FOUR HEDGES *Clare Leighton*
DREAM ISLAND *R. M. Lockley*
THE UNOFFICIAL COUNTRYSIDE *Richard Mabey*
RING OF BRIGHT WATER *Gavin Maxwell*
EARTH MEMORIES *Llewelyn Powys*
IN PURSUIT OF SPRING *Edward Thomas*
THE NATURAL HISTORY OF SELBORNE *Gilbert White*

LITTLE TOLLER BOOKS
Lower Dairy, Toller Fratrum, Dorset DT2 0EL
W. littletoller.co.uk **E.** books@littletoller.co.uk